Therapeutic Colouring book III Floral Pattern

Aldona Design

This Therapeutic Colouring book III belongs to

Copyright © Aldona Design
All rights reserved, no part of this publication may be reproduced, stored in a retrieval system or transformed in any form or by any means of mechanical, electronic or photocopying, scanning or recording or otherwise without the permission of the Publisher/ Designer

List of Adult Colouring books
Book I
Therapeutic Colouring book : 100 one sided pages for with patterned alphabet's and mandalas ,and words with **ISBN 1097666700**

Book II
Therapeutic Colouring book II: 100 colouring pages (8.5 x 1in)for Adults with **ISBN 1080663134**

This is Book III
Therapeutic Colouring book III

Colouring books For Kids
Christmas Colouring Book For Kids: 72 one sided pages of Christmas colouring pictures with **ISBN 1081432489**

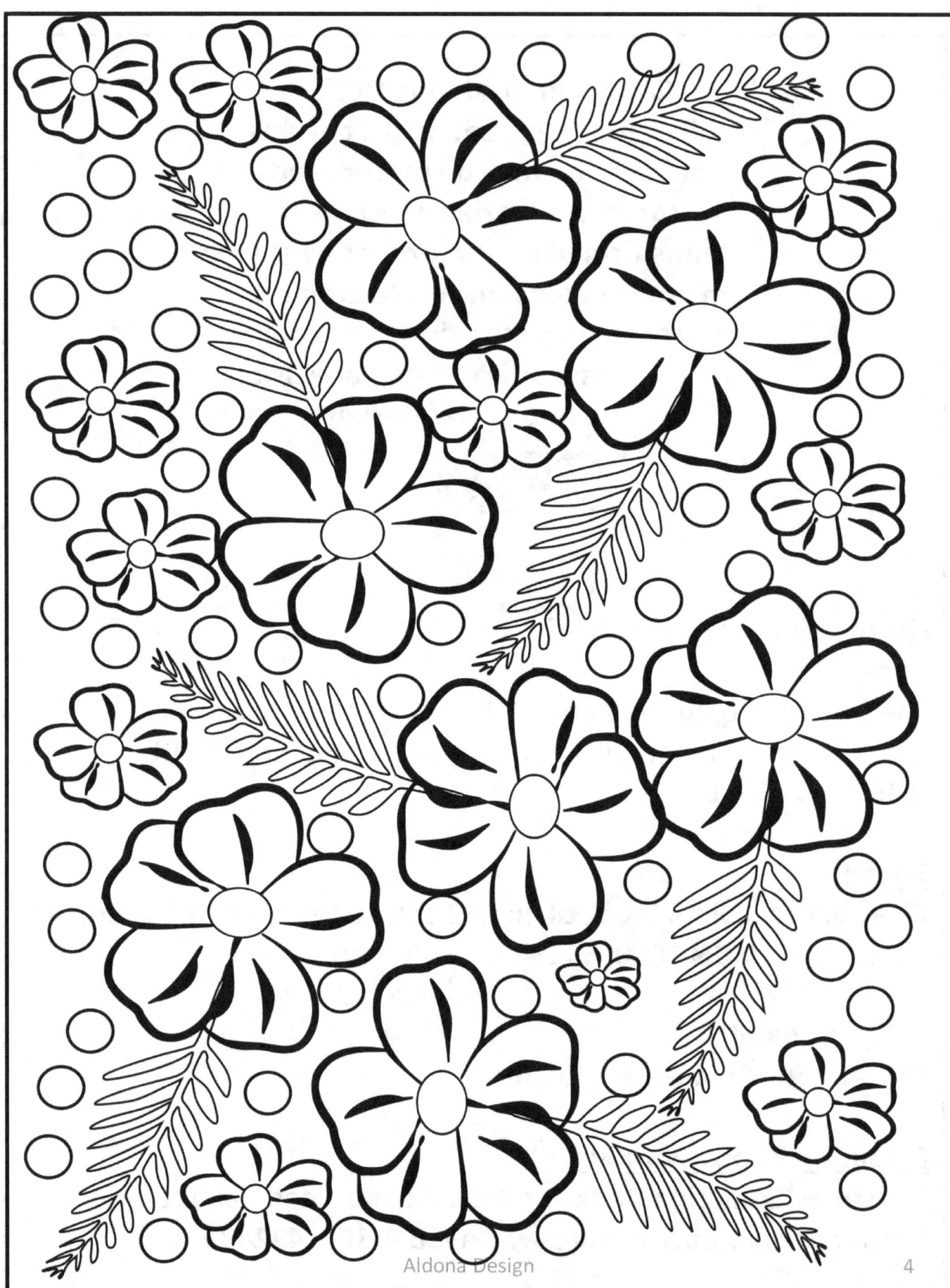

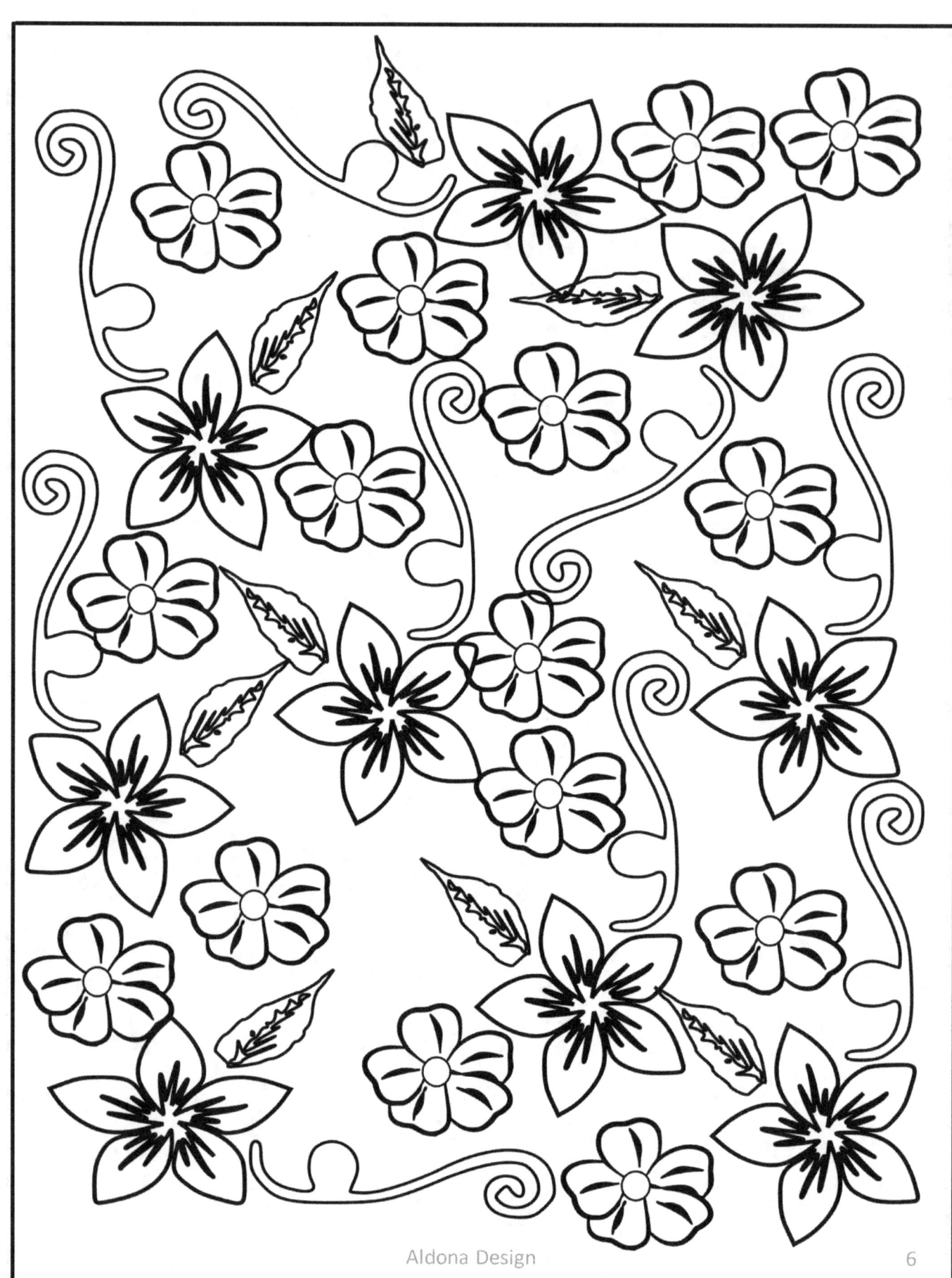

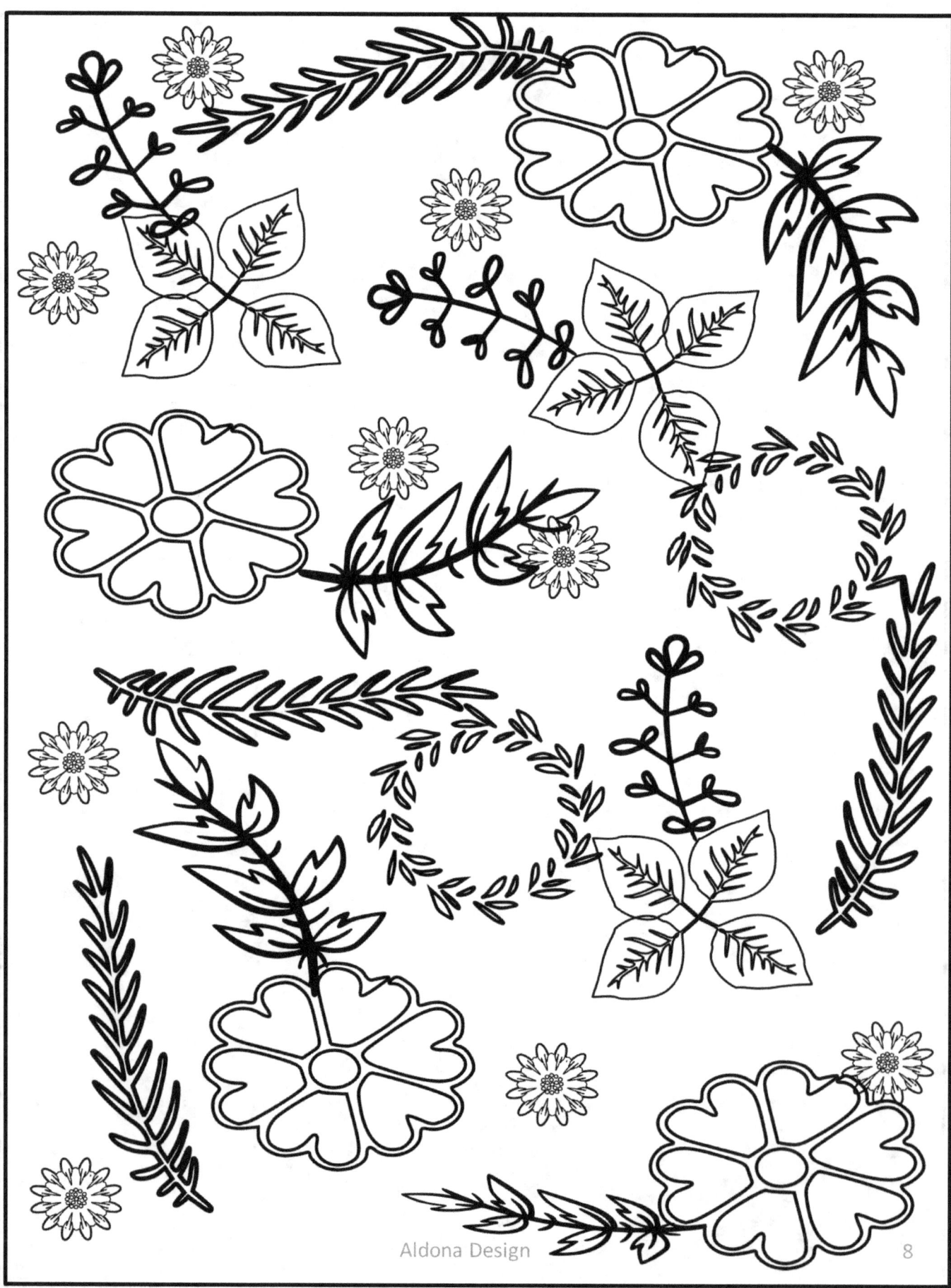

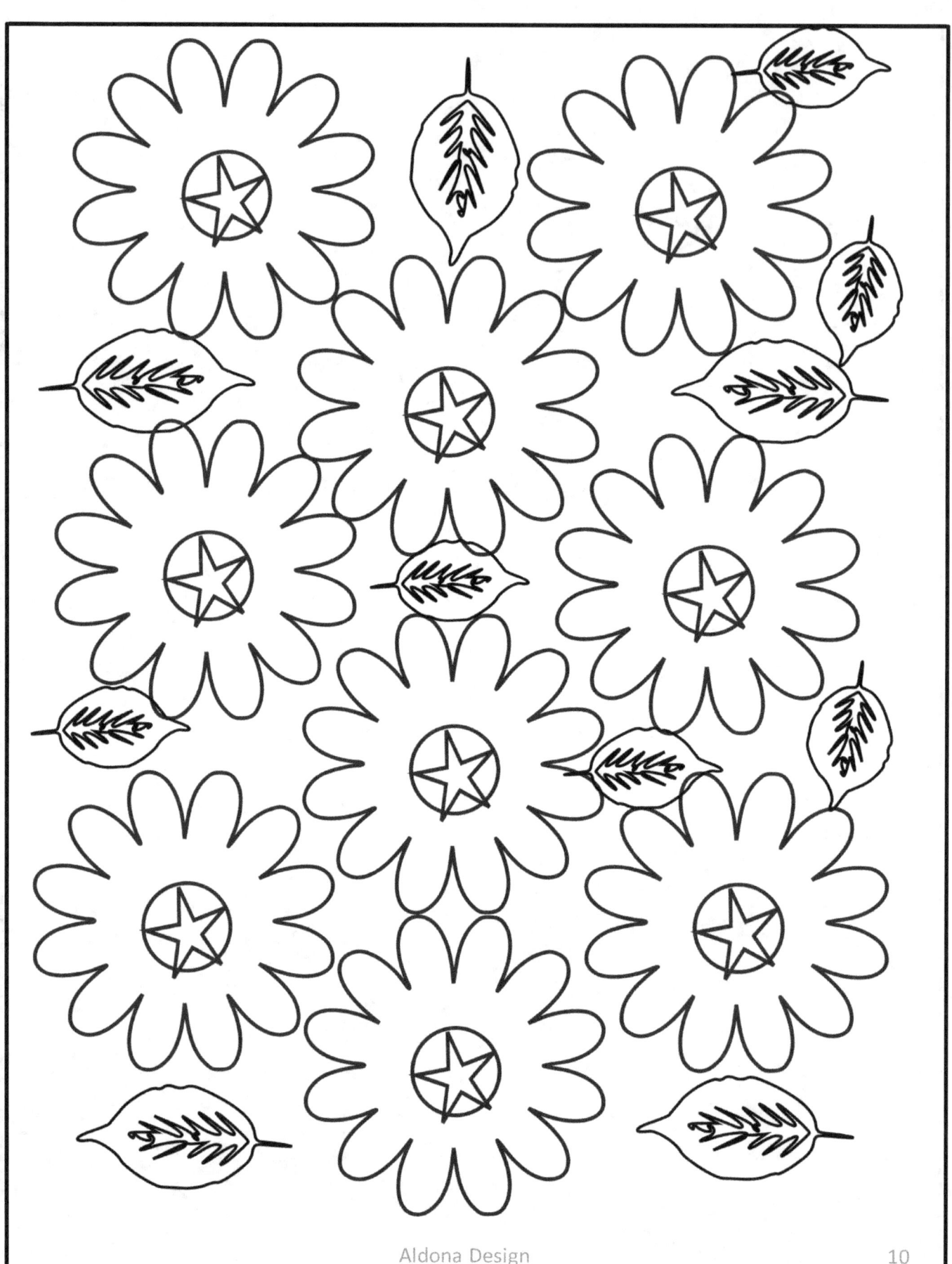

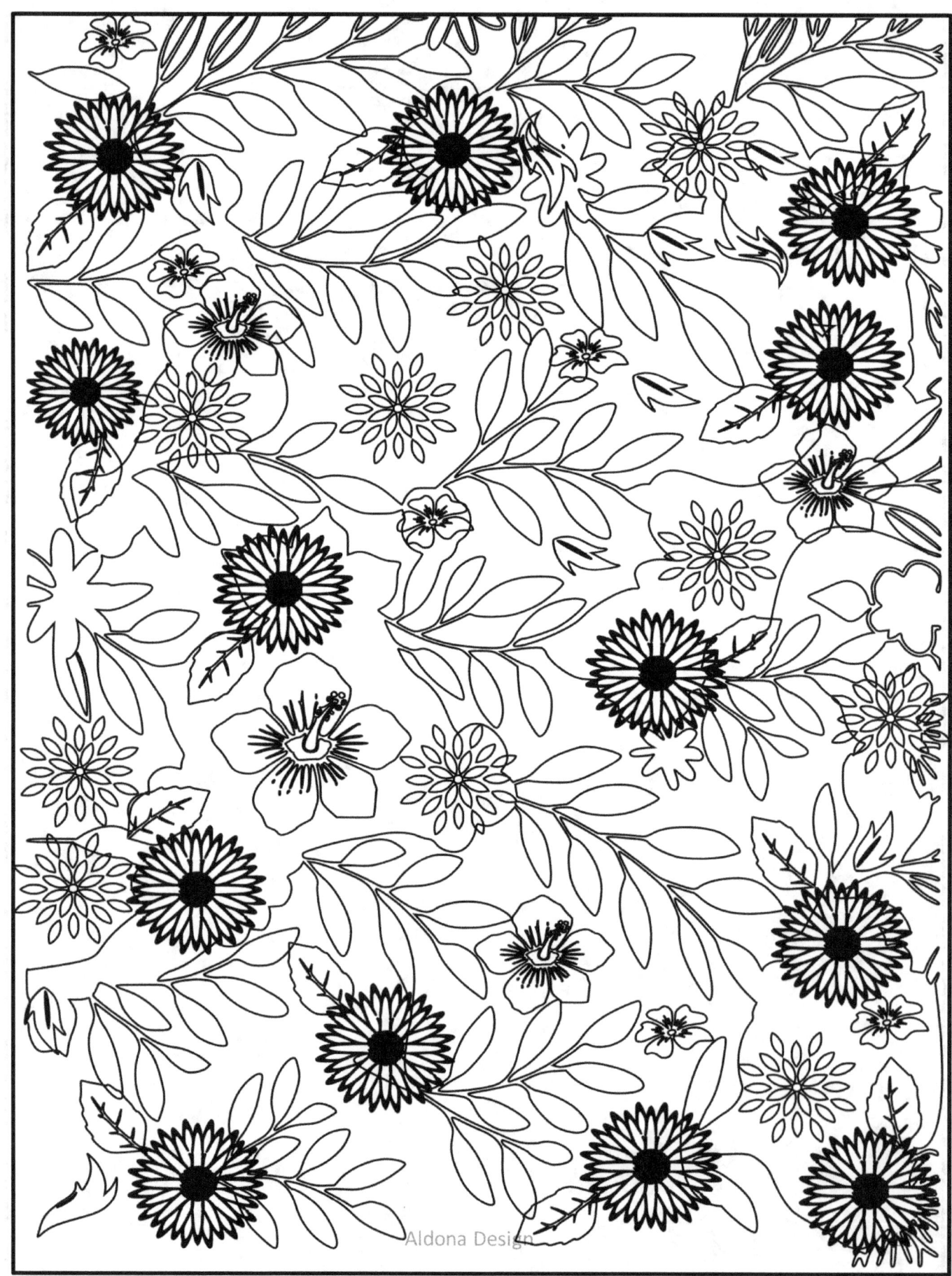

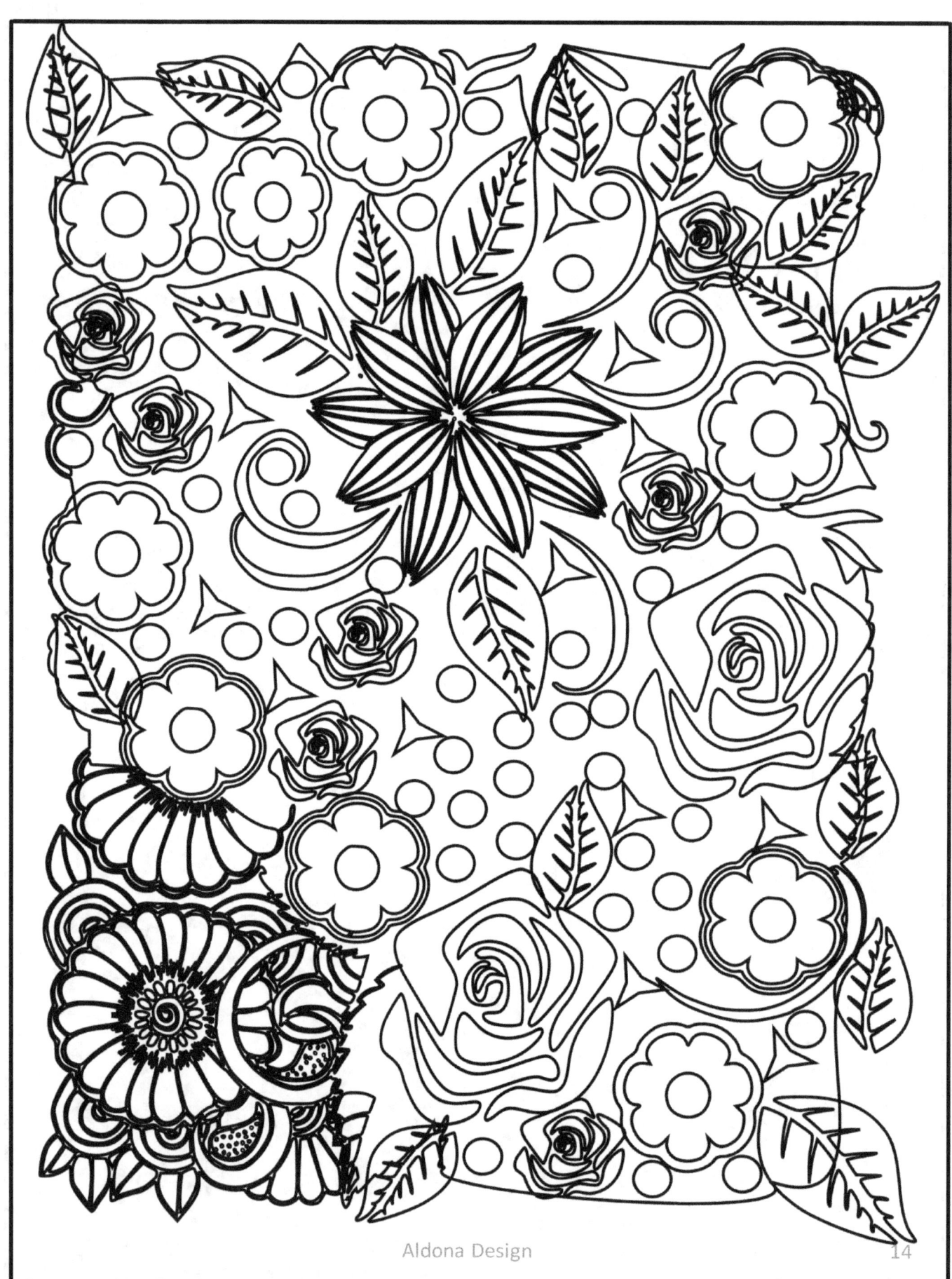

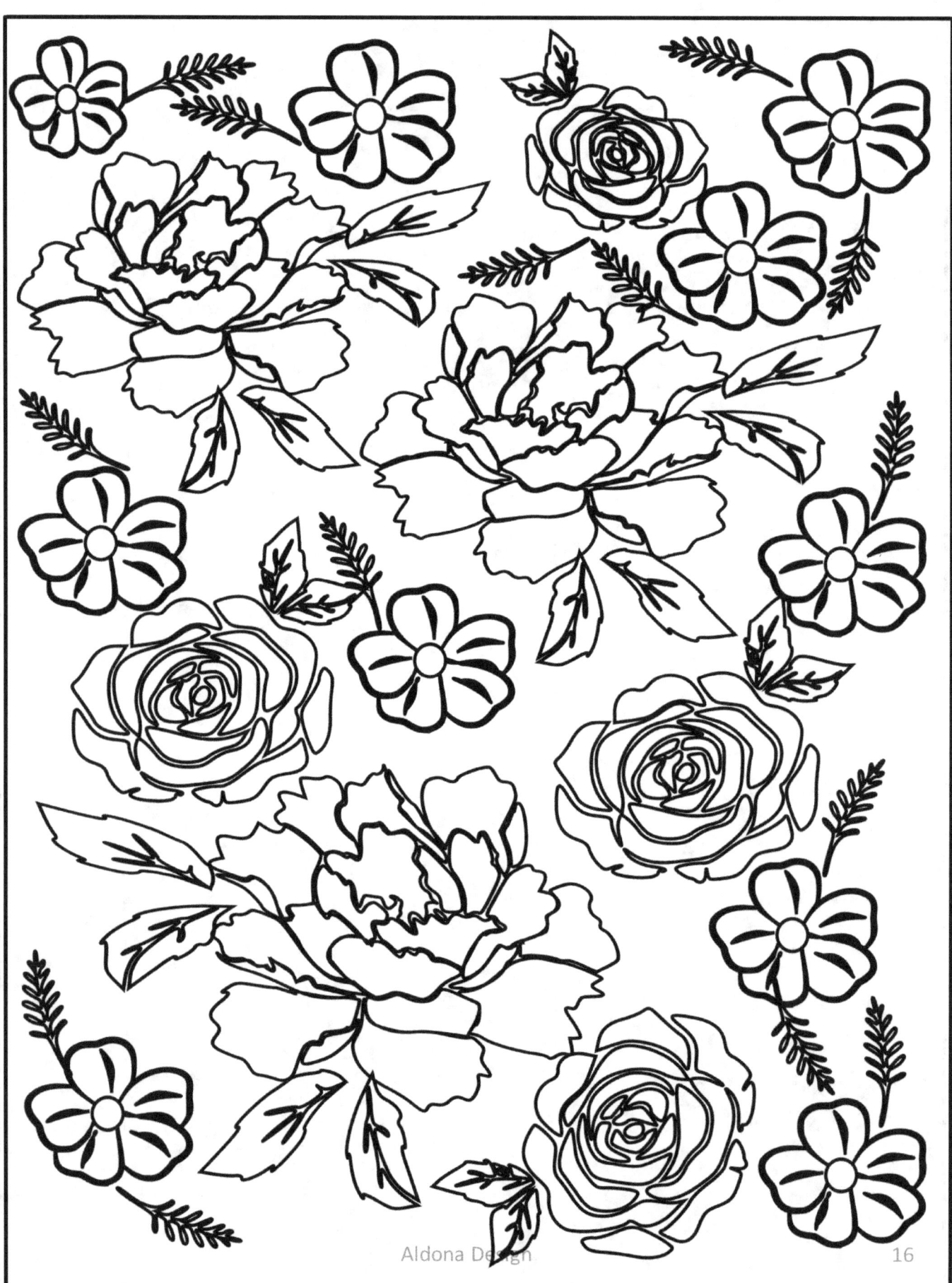

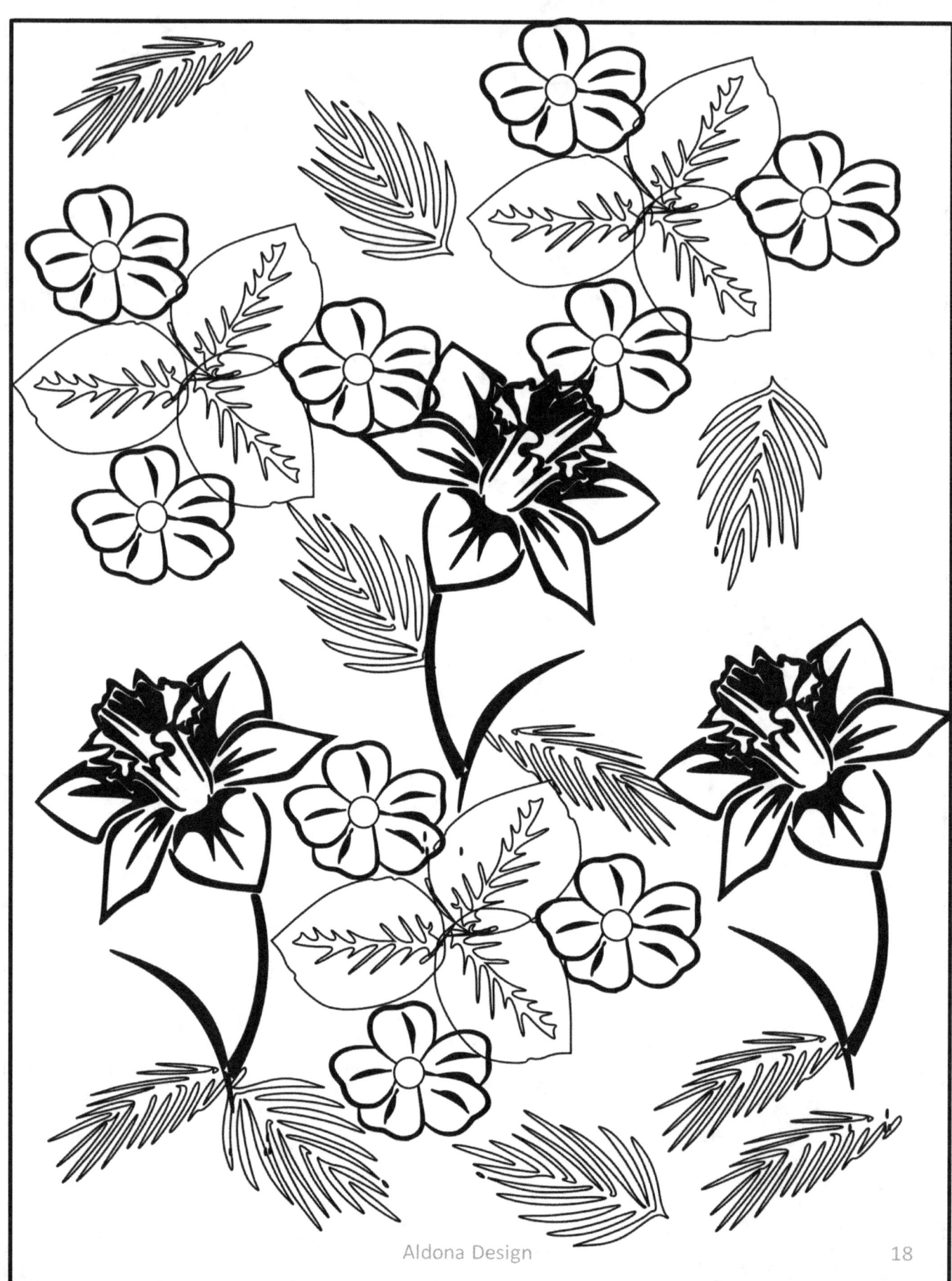

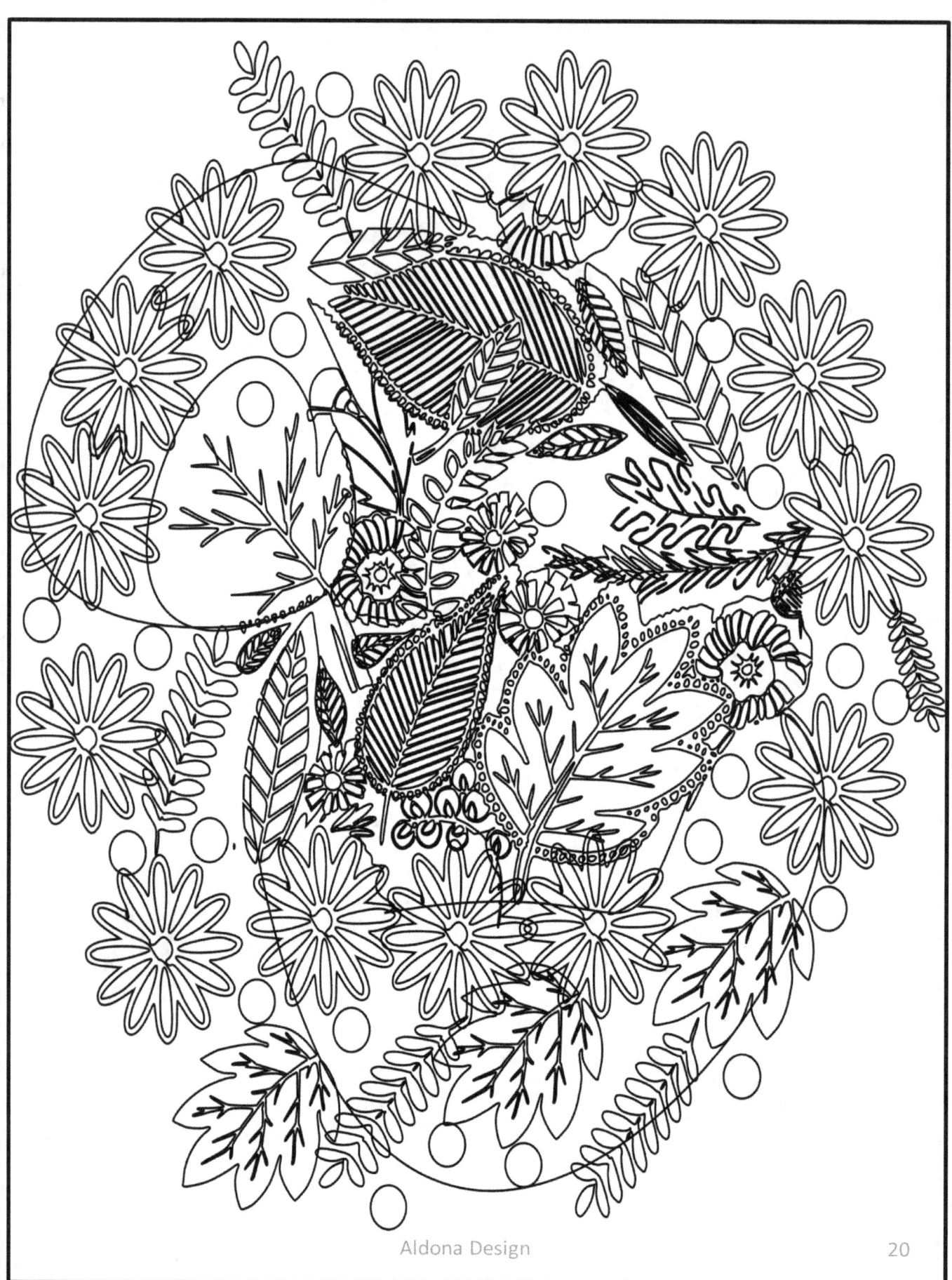

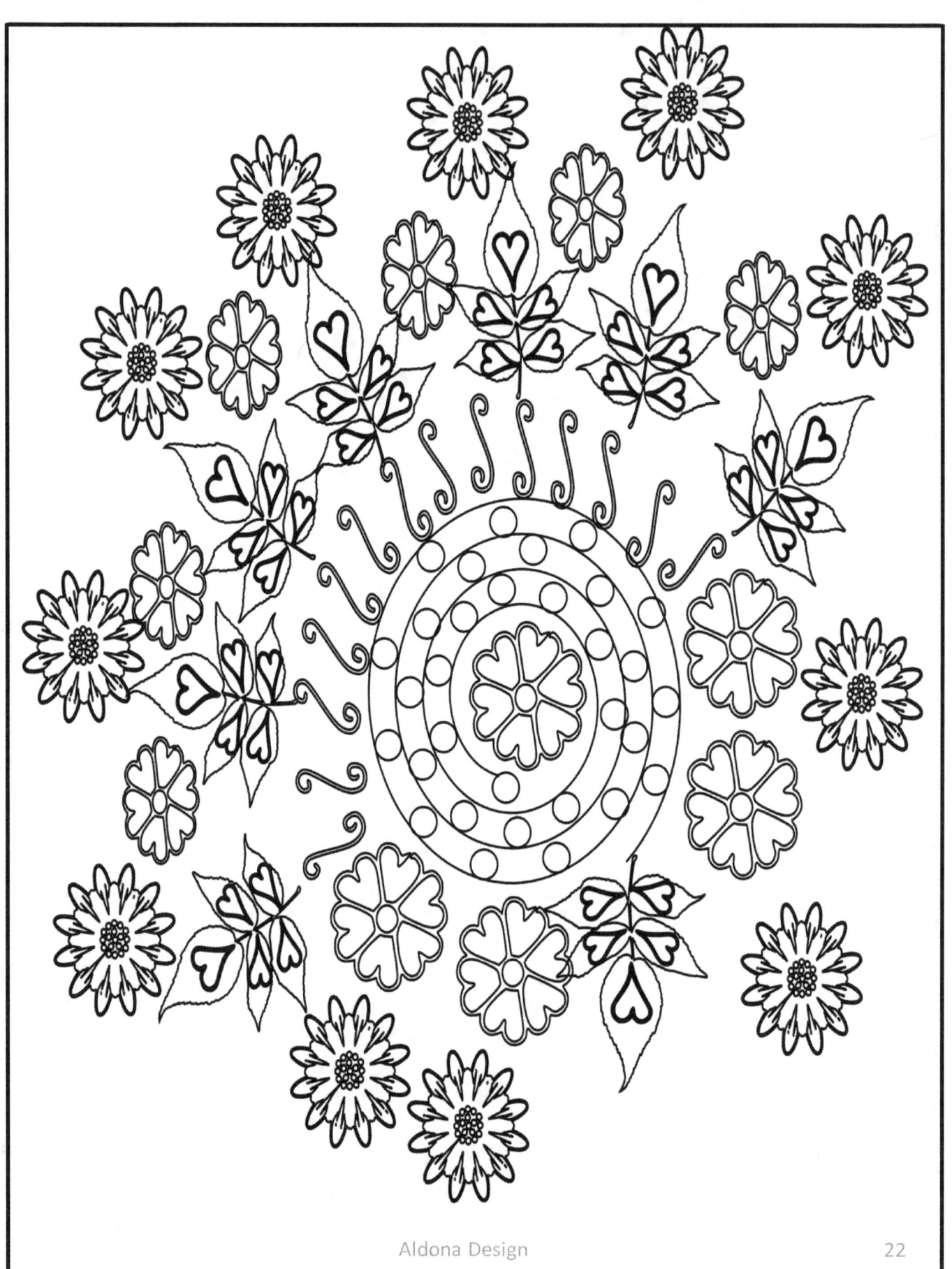

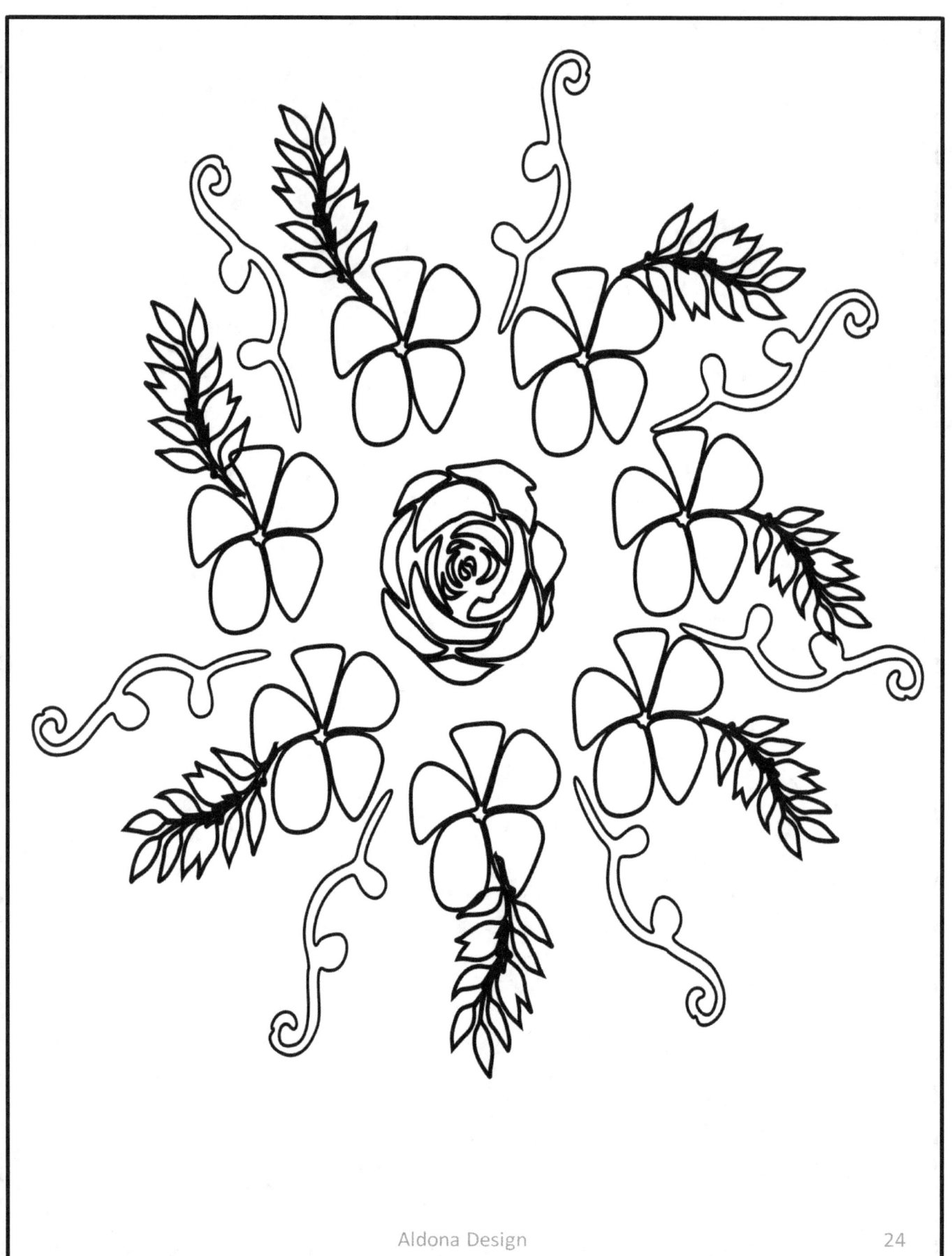

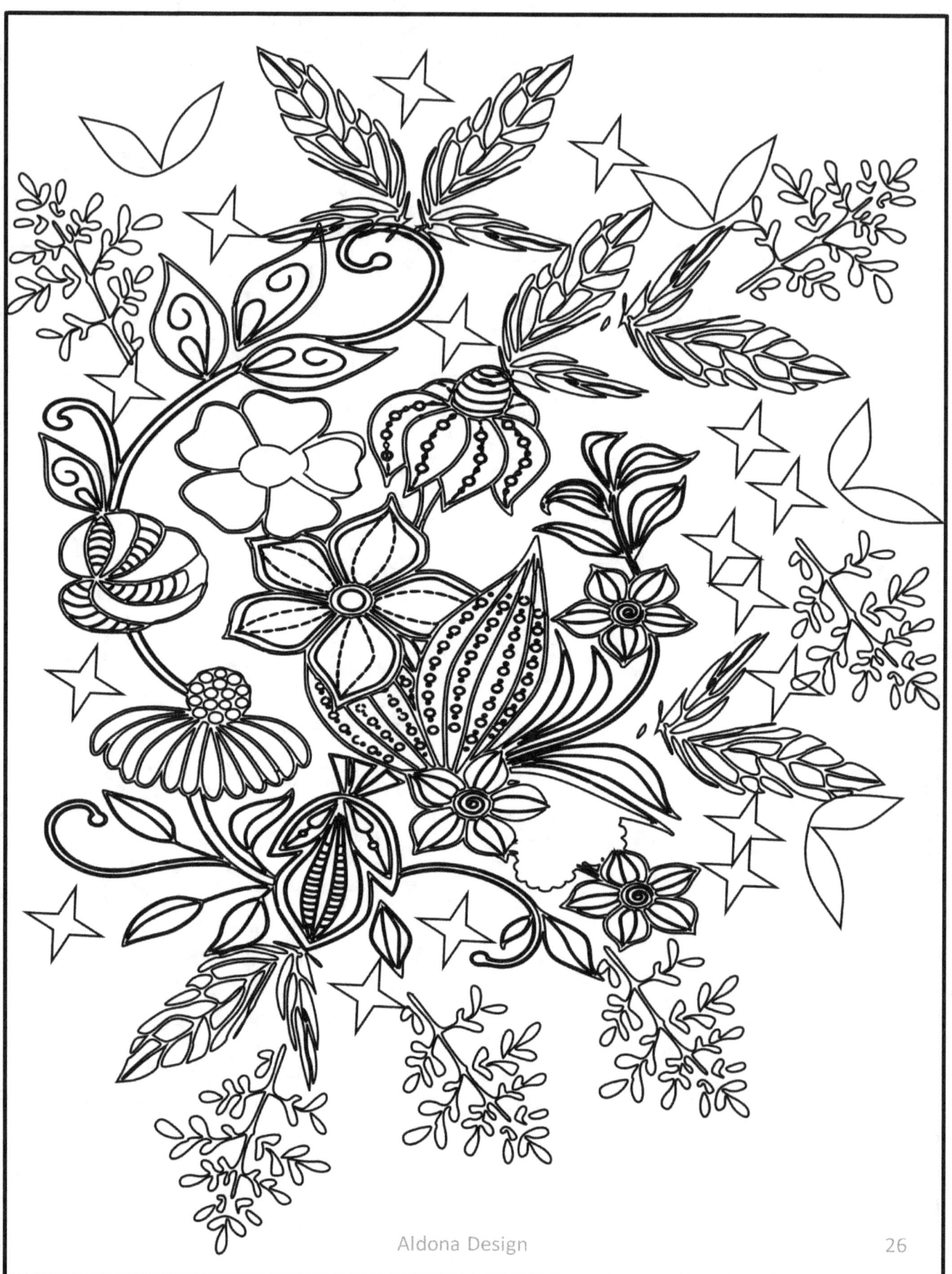

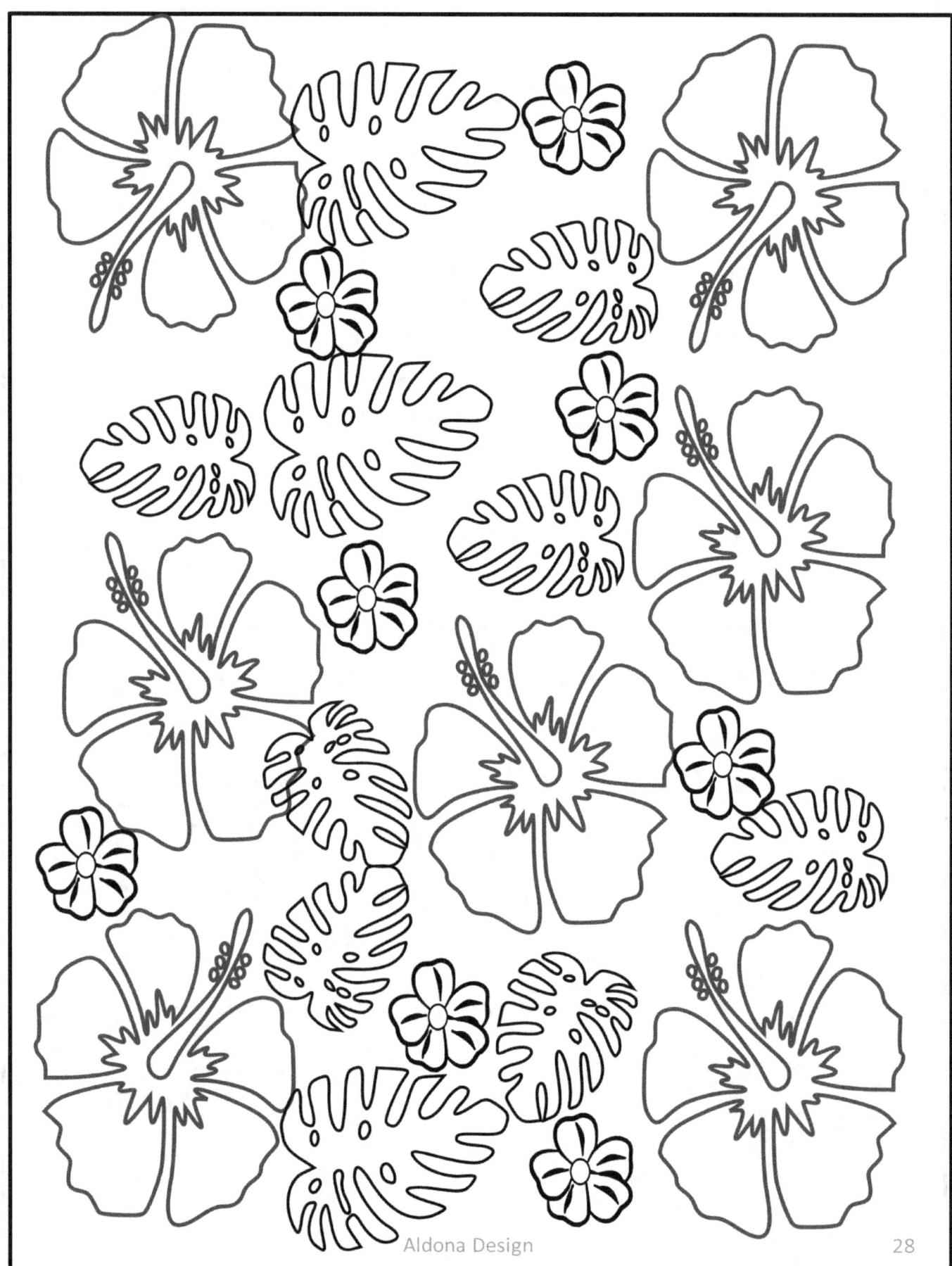

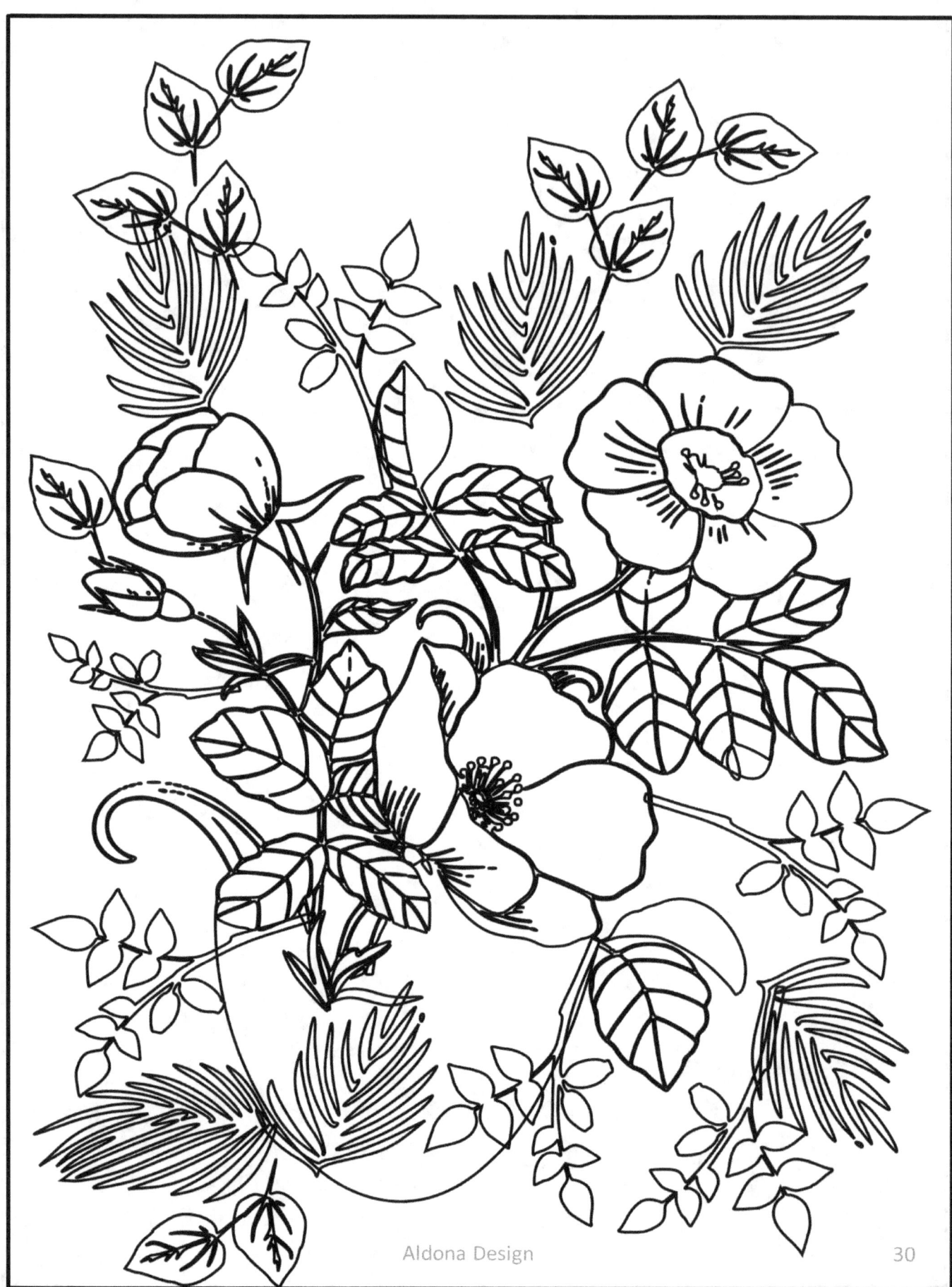

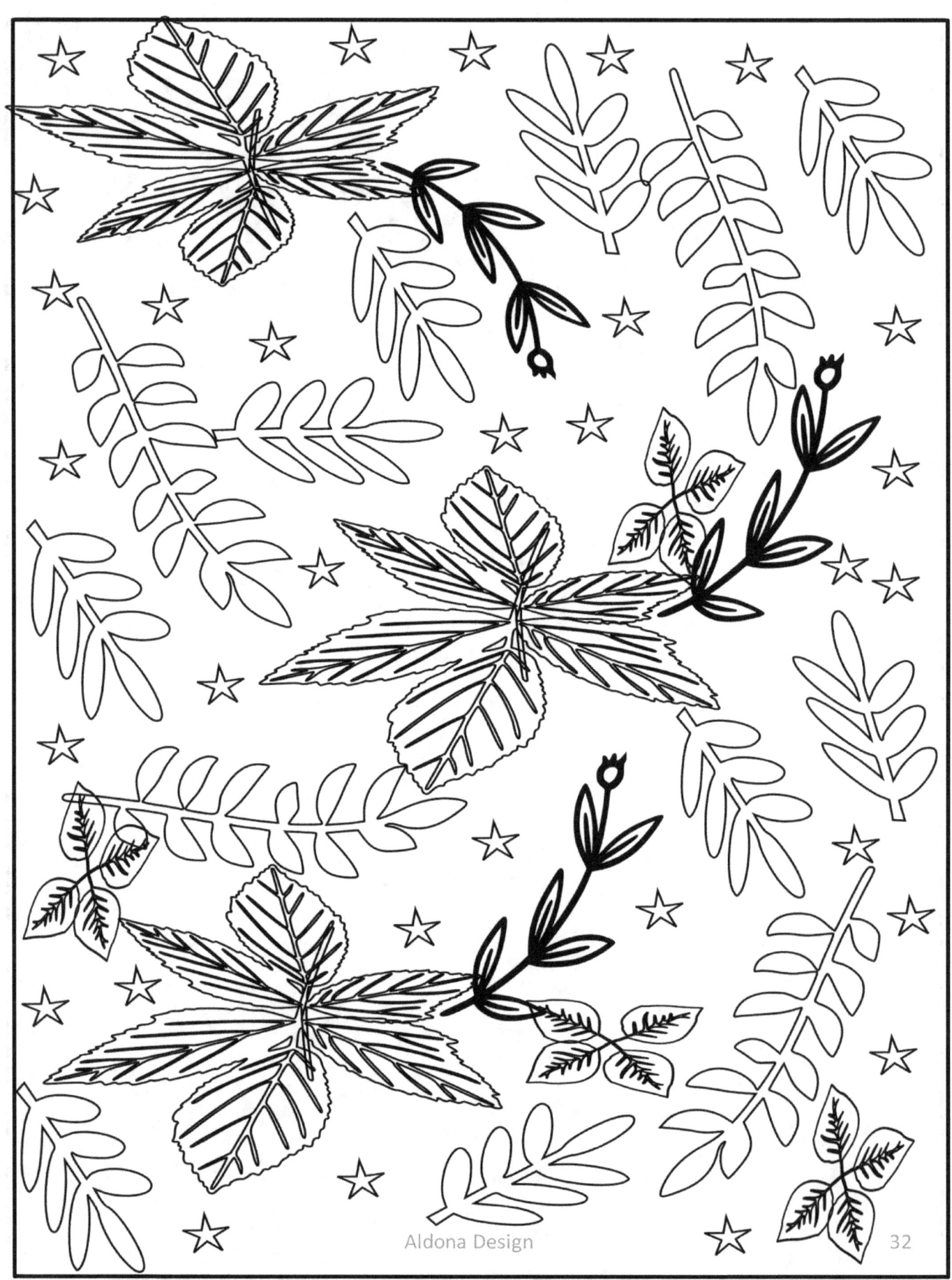

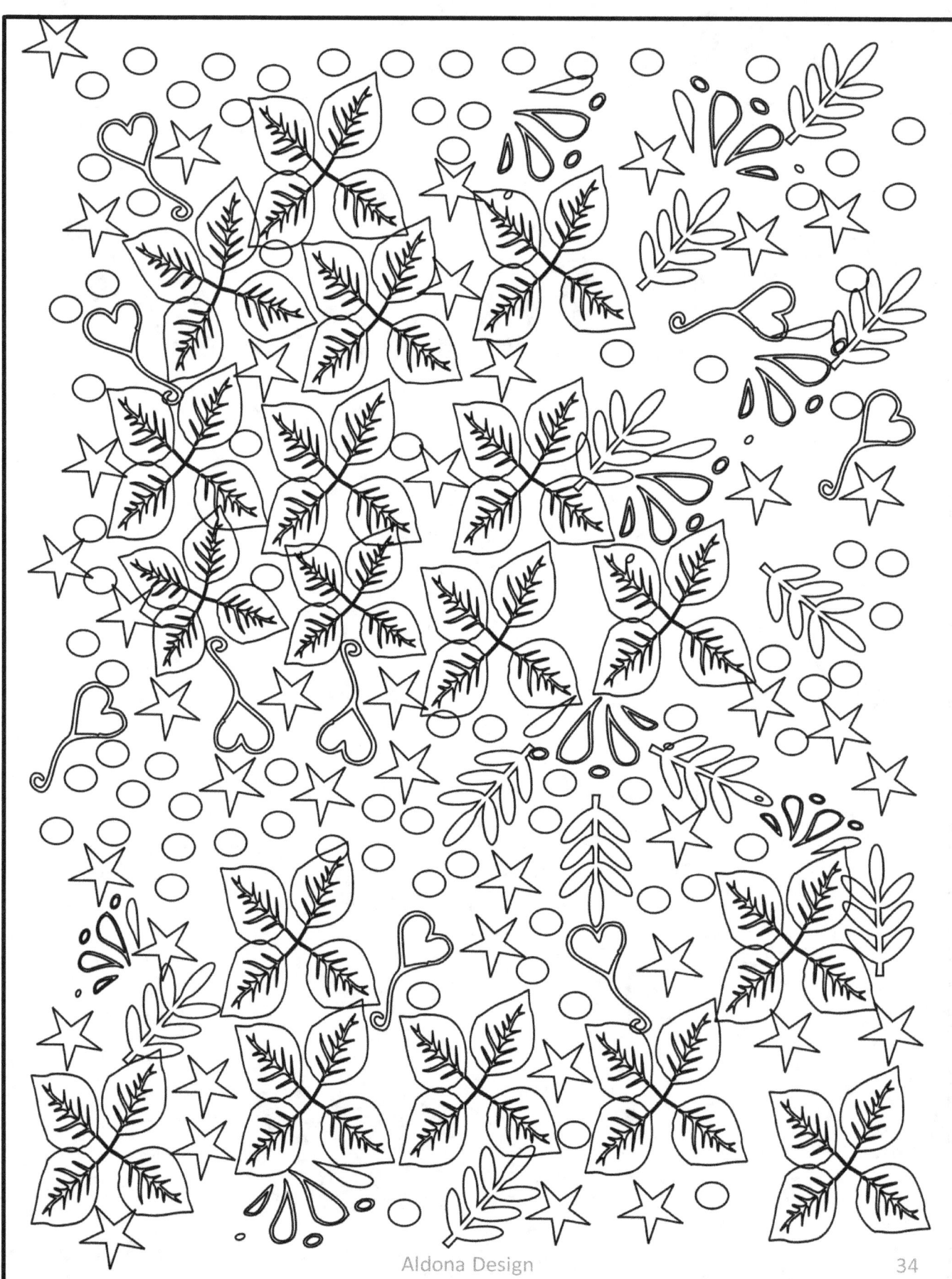

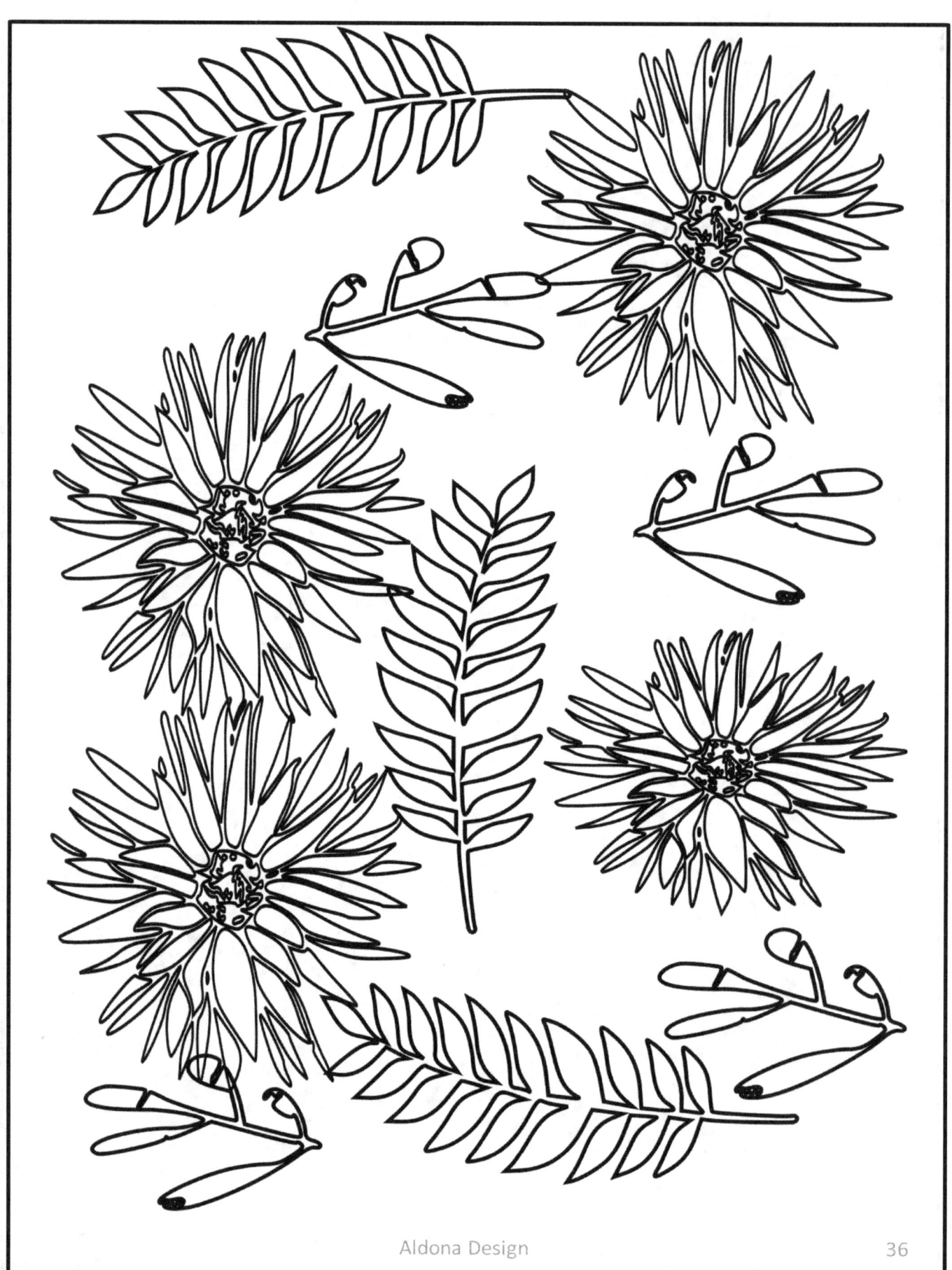

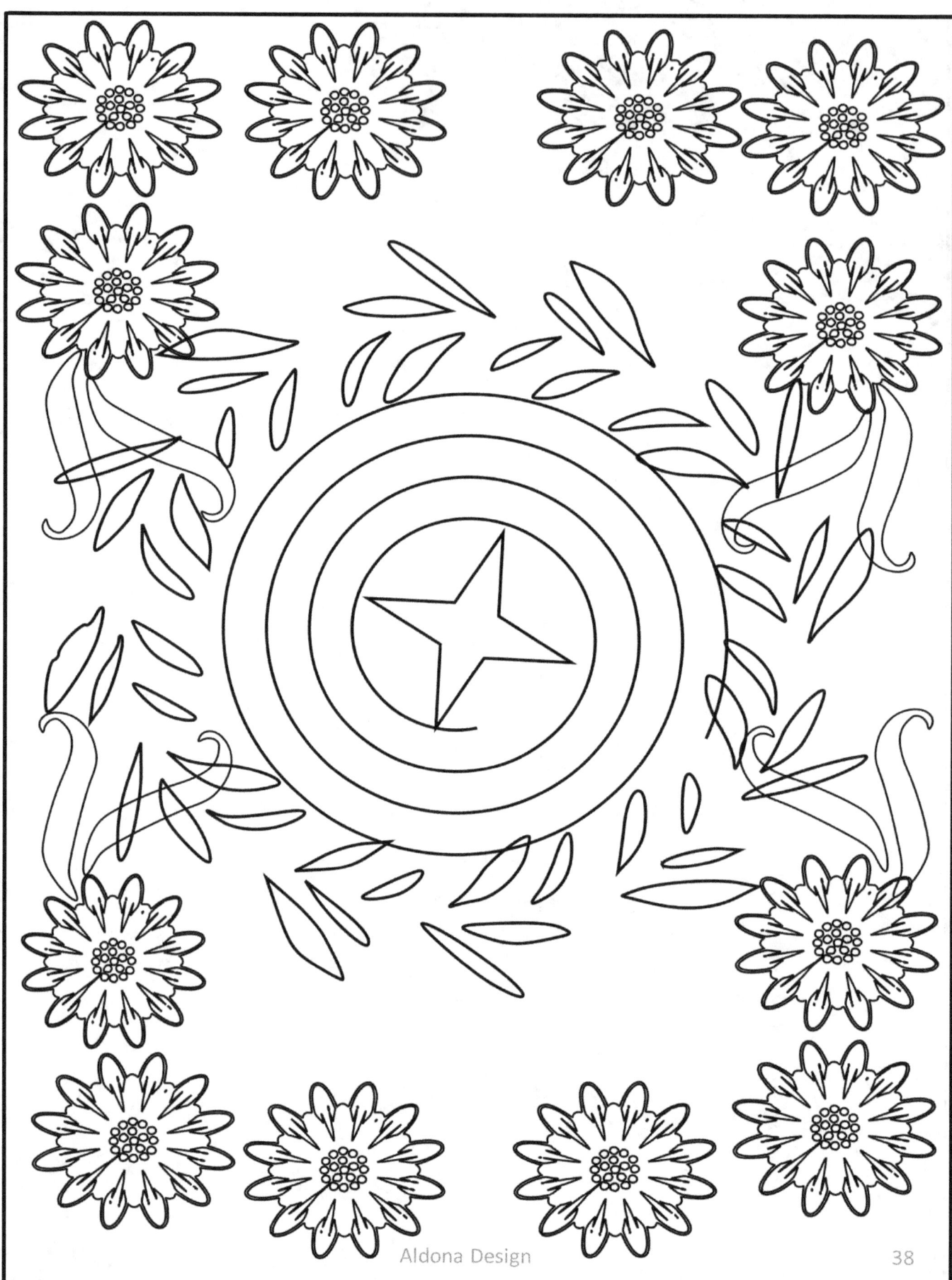

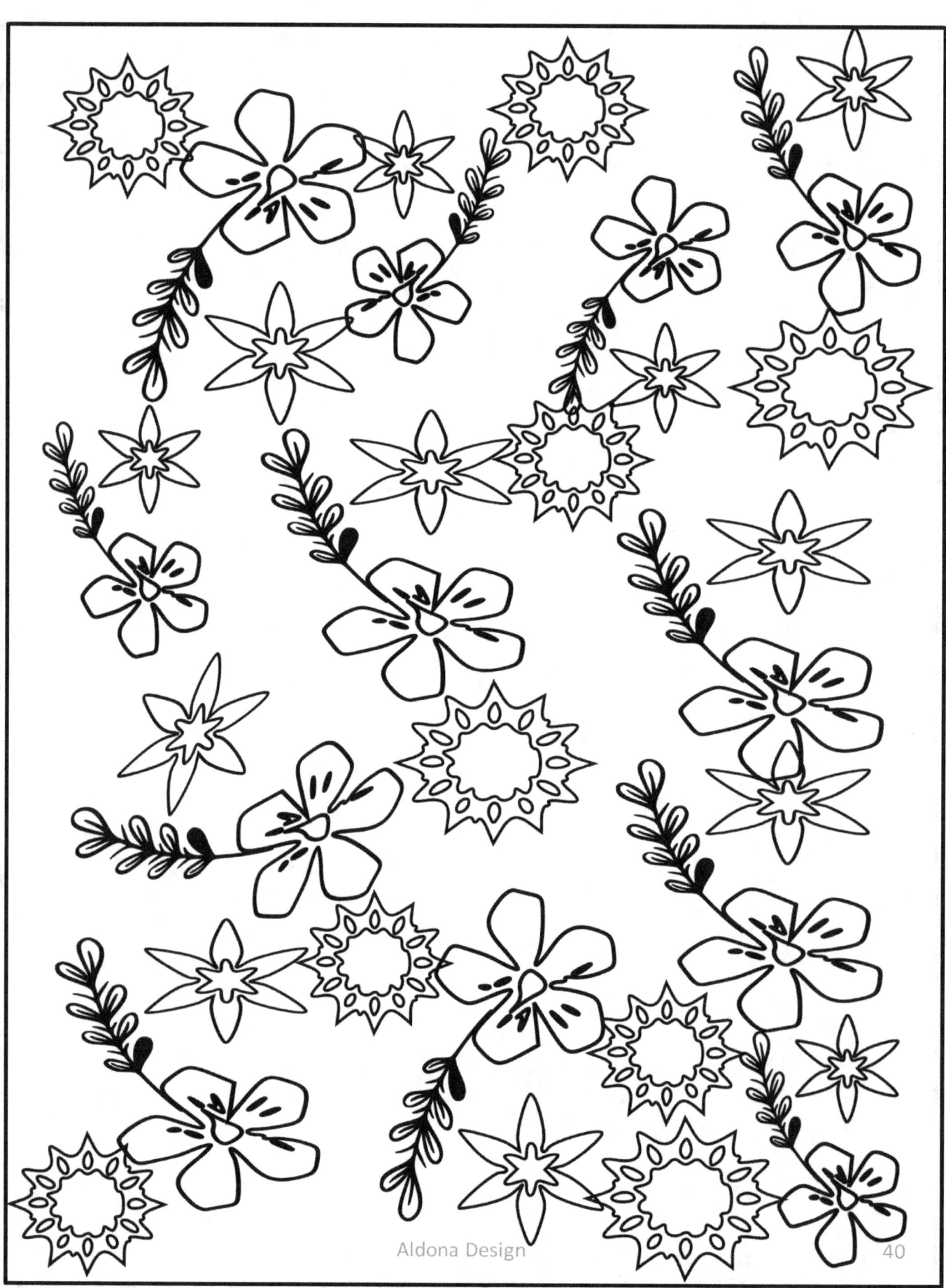

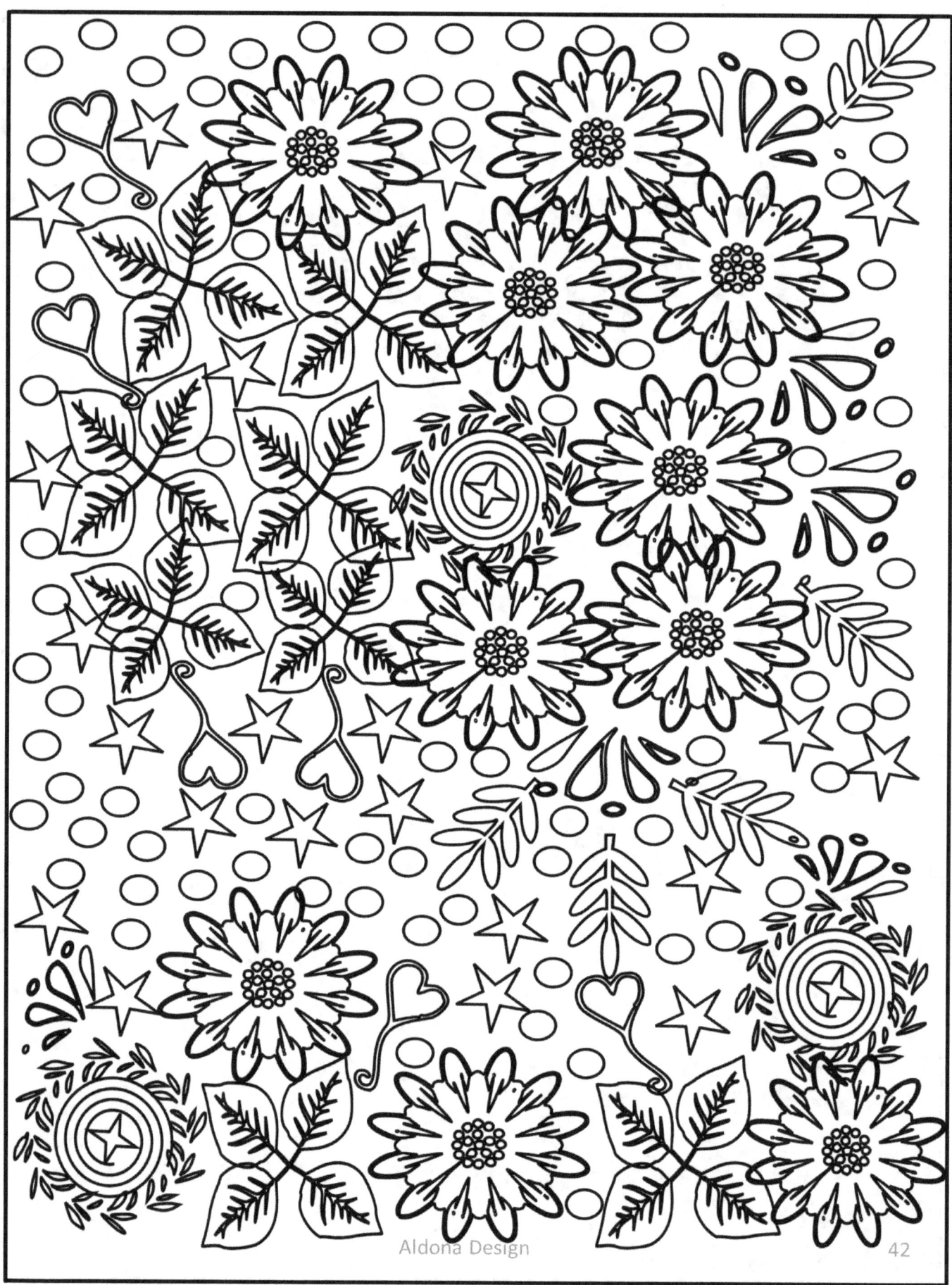

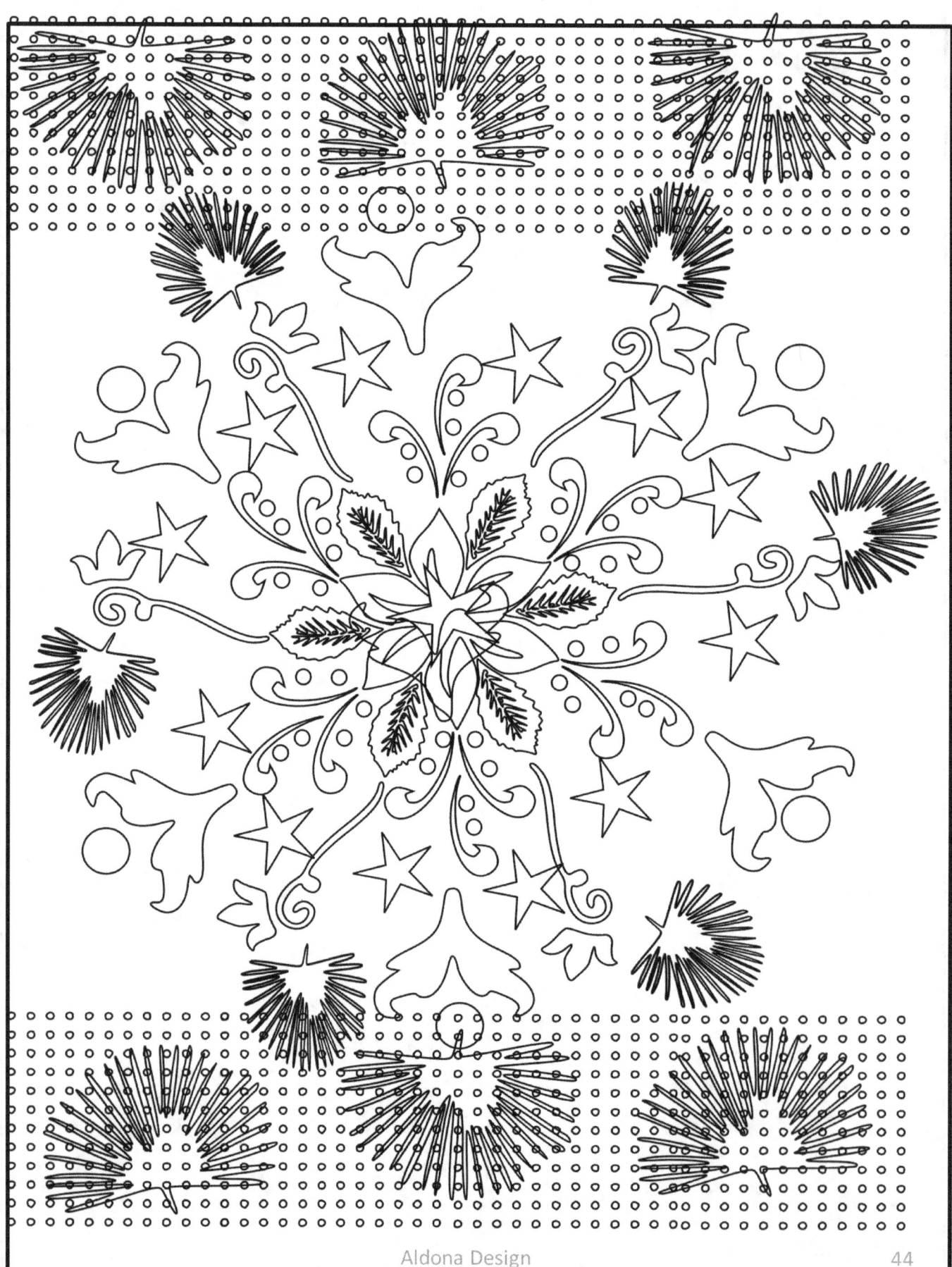

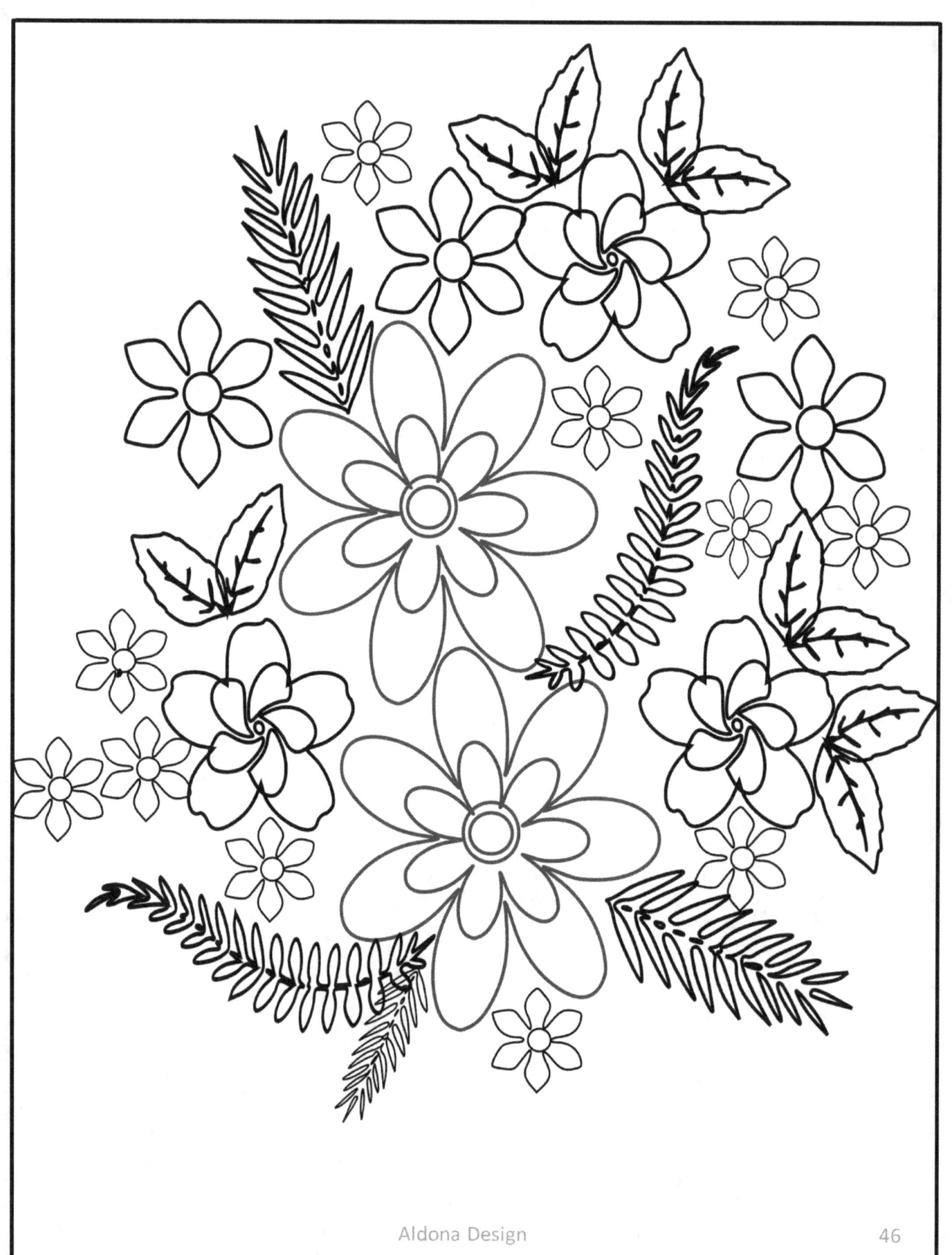

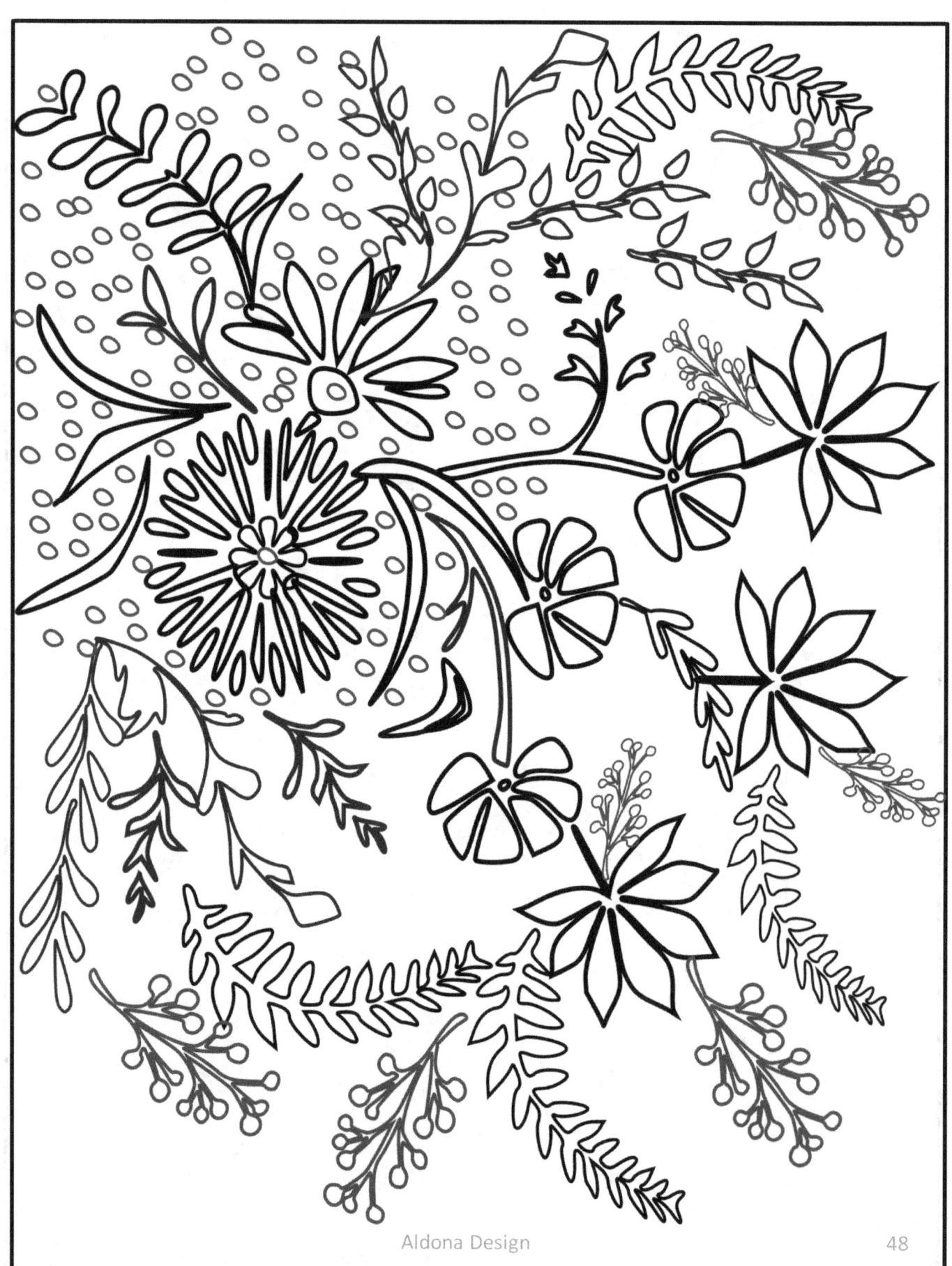

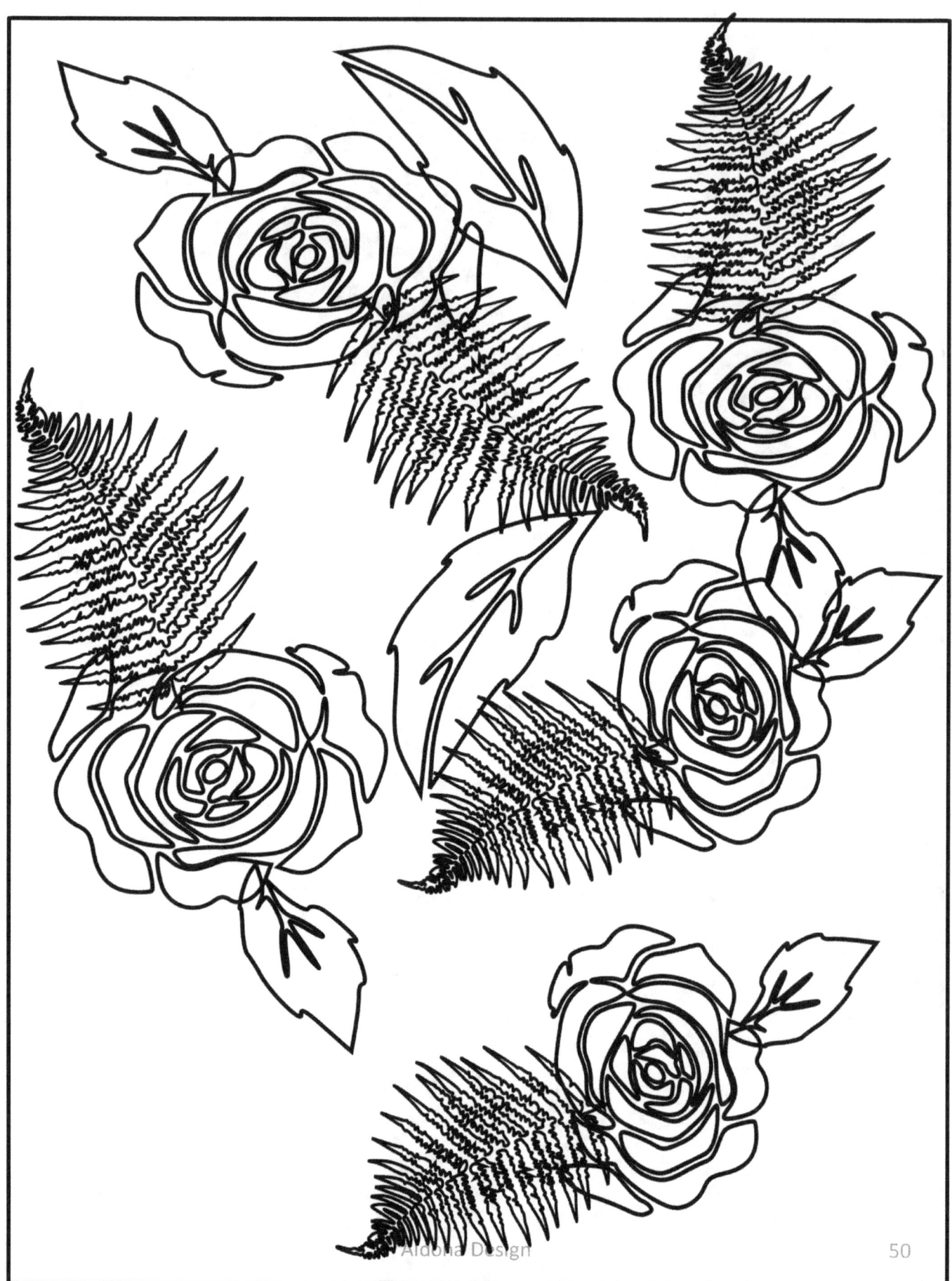

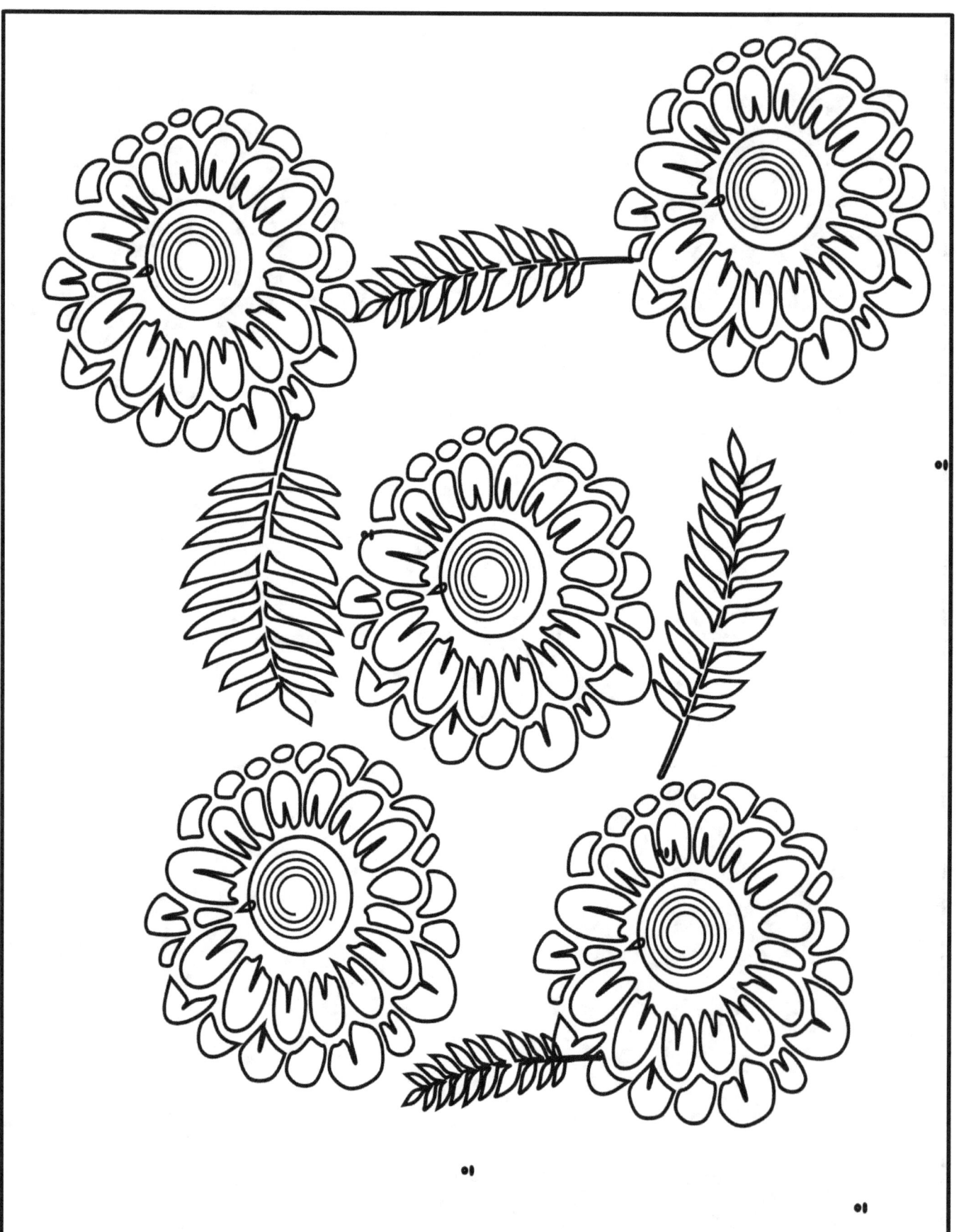

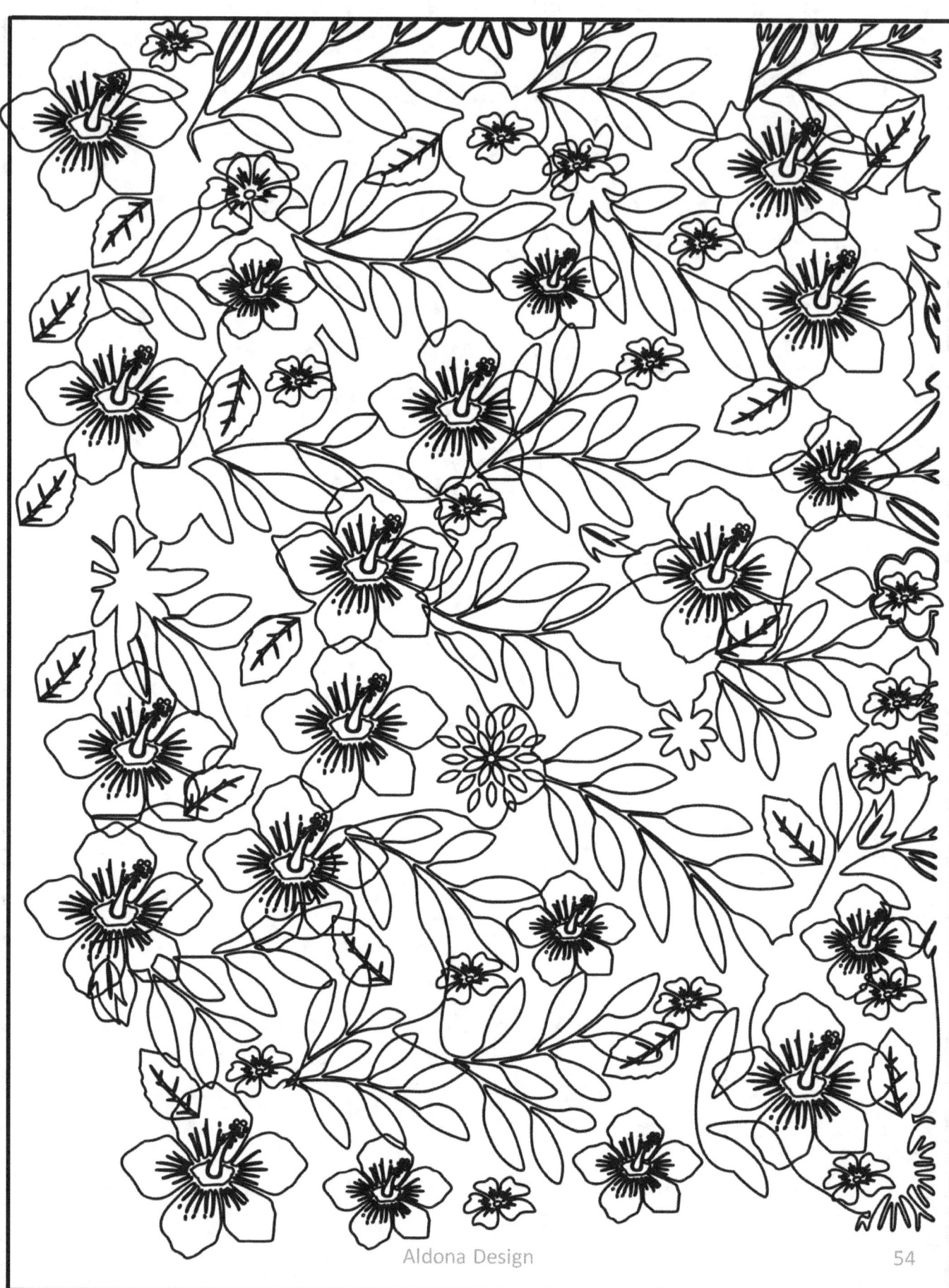

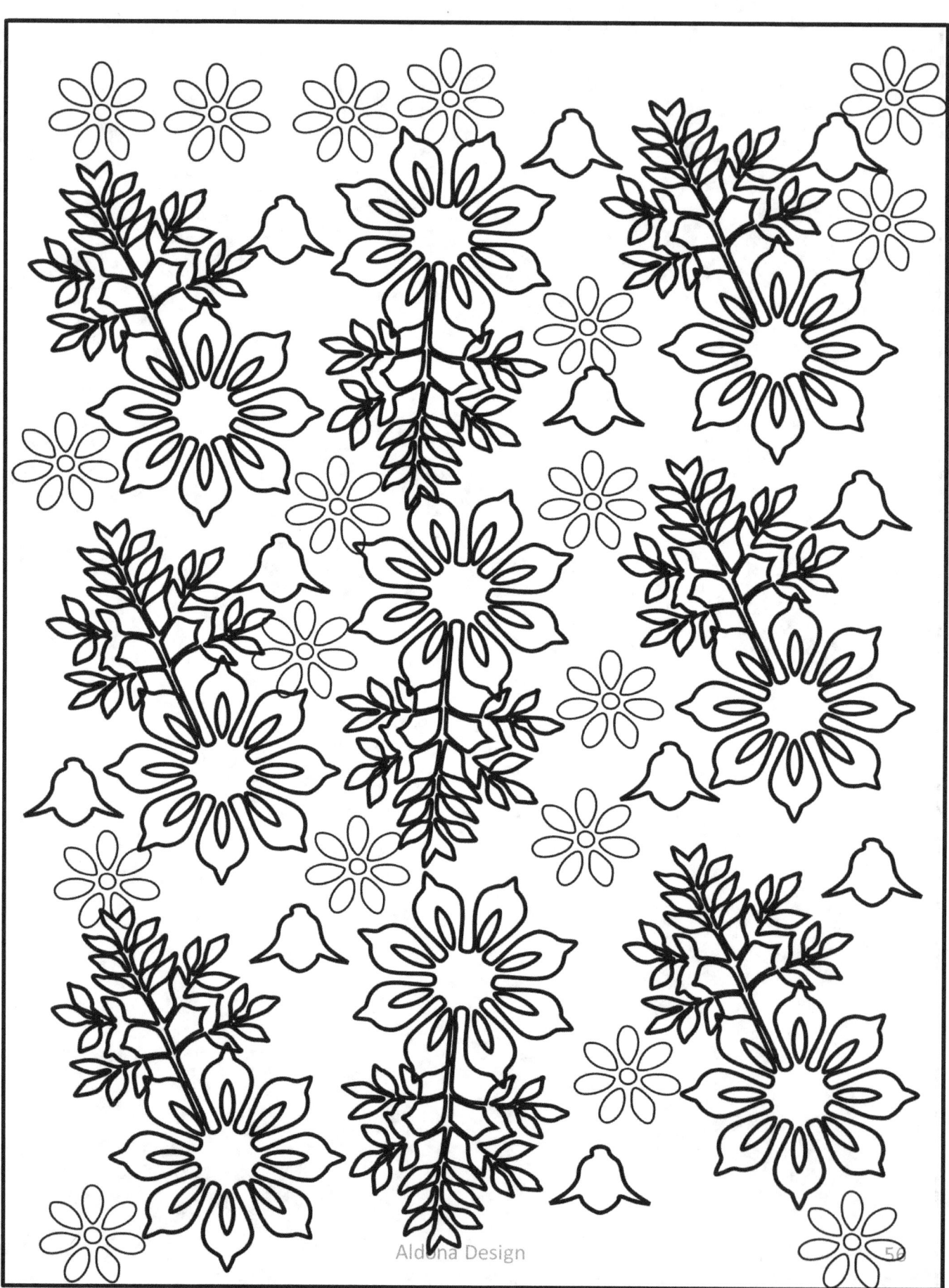

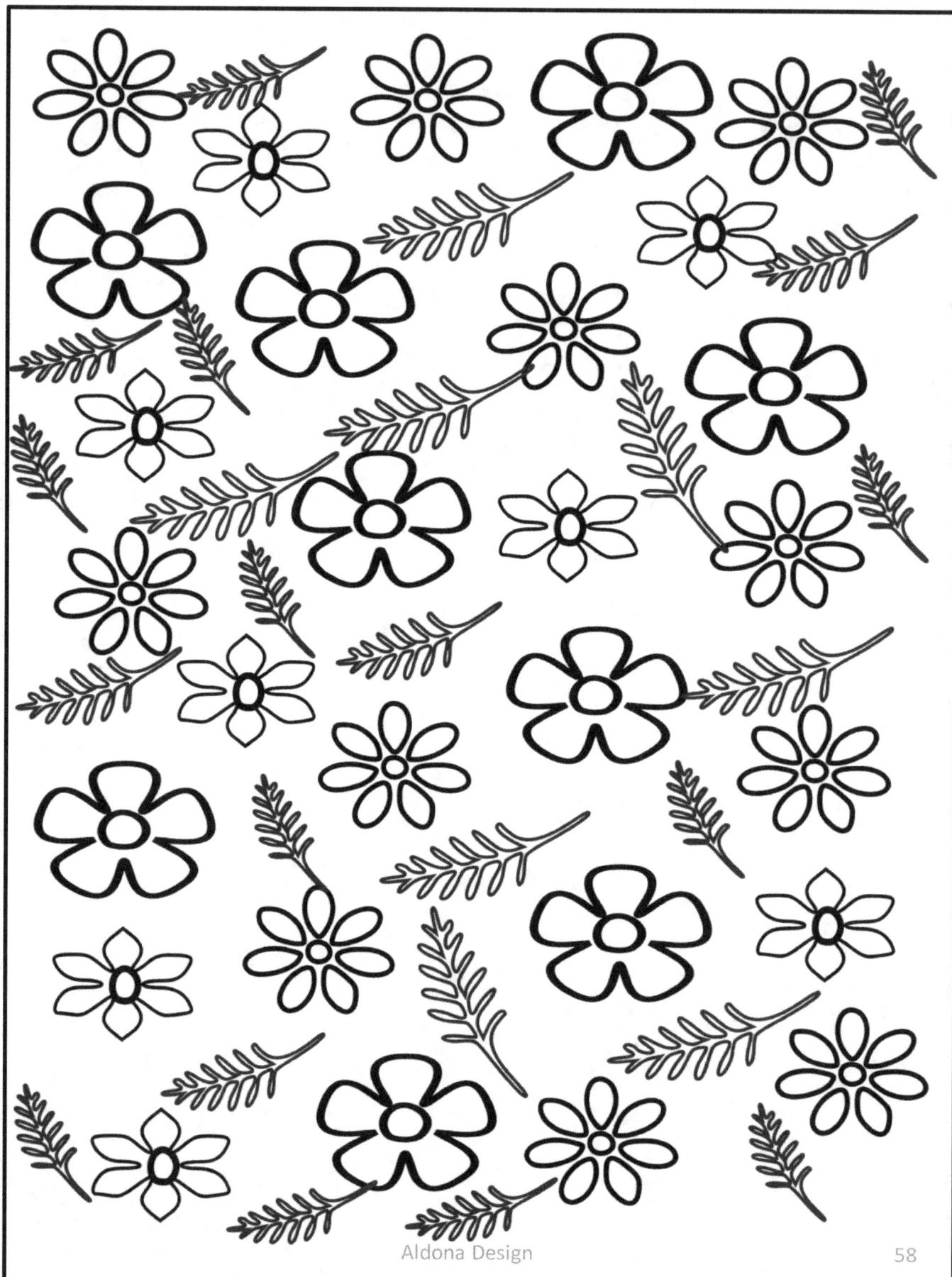

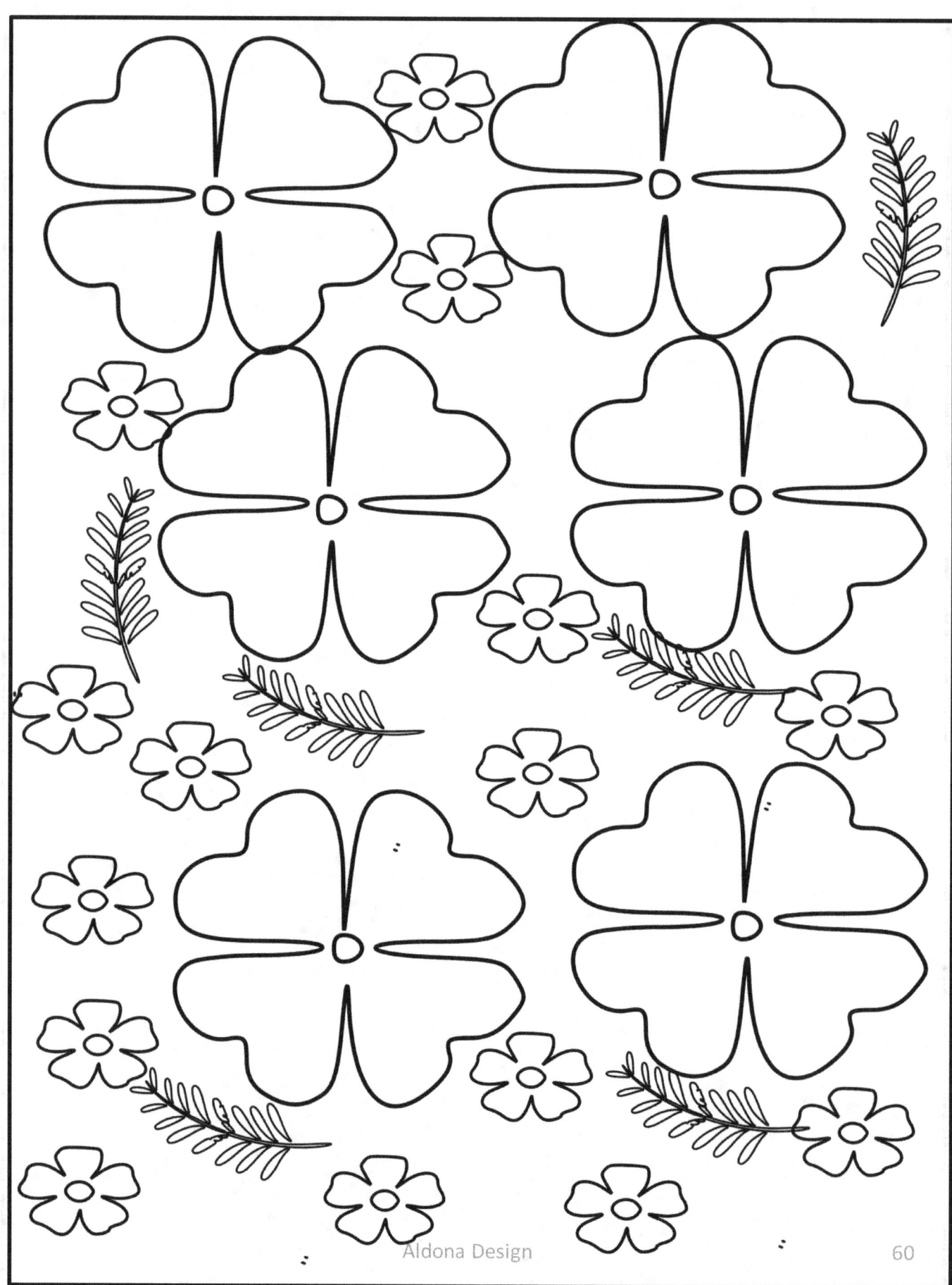

THANK YOU

List of other books by Aldona Design
- 24 picture writing prompts (Workbook for kids)
- My Music notebook (120 pages)
- Busy Mothers (Weekly/Monthly Planner for Mums)
- Pisces (200 page Ruled line Notebook) & other Zodiac notebooks
- Monochrome Scrapbooking paper & design Elements (20 pages for Craft Projects)
- Therapeutic Colouring book I(100 pages for Adults)
- Therapeutic Colouring book II (for Adults)
- Christmas Colouring Book for Kids
- For Dads (Planner for Dads)
- For Dentist (Planner for a Dentist)
- Hair stylist (Planner)
- The Special Bride to be (Planner)
- Recipe Notebook (to write your Recipes)
- Weekly Meal Plan (Notebook to Plan Meals)
- My own Nail Art Design
- One Sentence a day (Journal)